# Silver

**An Easy & Complete Step By Step Guide**

# Janet Evans

# Table of Contents

Copyright © 2012 ............................................................................ 3

Introduction..................................................................................... 4

Chapter 1 – Tools You'll Need for Making Silver Jewelry . 5

Chapter 2 – Materials Needed For Making Silver Jewelry 9

Chapter 3 – Techniques You Need To Master When Making Silver Jewelry................................................................ 18

Chapter 4 – Some Projects To Try Out................................... 31

Project 1 – Sterling Silver Hand Forged Hoop Earrings . 34

Project 2 – Simple Drop Earrings............................................ 36

Project 3 – Sterling Silver Ring................................................ 37

Project 4 - Diamond Drop Necklace ....................................... 39

Project 5 – Wild Orchid Evening Necklace........................... 41

Project 6- Sterling Silver & Gem Flower Necklace............ 44

Here's More Kindle Jewelry Making Books from Janet Evans ............................................................................................... 49

Janet Evans

# Copyright © 2012

http://ultimatehowtoguides.com

All rights reserved.

No part of this publication may be copied, reproduced in any format, by any means, electronic or otherwise, without prior consent from the copyright owner and publisher of this book.

# Introduction

Wearing jewelry is essential to helping women developed their own style. For women wishing to create a look that's unique, the last thing they'll want to invest money in is mass produced pieces of jewelry. It's for this reason alone, learning the skills needed for making silver jewelry could prove extremely beneficial.

When it comes to making such pieces you need to know where to purchase the right kinds of supplies. In this book not only do we discuss what's needed to start your own silver jewelry making venture but also provide several projects you may want to try out.

We also recommend you attend a silver jewelry-making course if you can as well. If you're having problems finding courses we highly recommend you look online for what you need. You may even find an online course that enables you to learn in the comfort of your own home.

As a beginner, the kind of course you should be looking for is one, which covers the basics. The kinds of skills this course should be teaching you relate to soldering cutting, shaping and texturing the silver plus polishing it. Also look for courses that teach you skills such as making jump rings, hooks and clasps for earrings.

Finally what you should be looking for in a course is one that'll allow you to make a number of different pieces of jewelry from silver.

The actual process of turning a piece of silver into a piece of jewelry is not only very technical, but also allows your artistic side to flourish. Once you've finished making silver jewelry either for yourself or for someone else, can prove extremely satisfying, especially as you watch the piece develop and grow.

# Chapter 1 – Tools You'll Need for Making Silver Jewelry

As you'll soon discover there are certain specialist tools needed for making jewelry from silver you wouldn't need for making other items of jewelry. Not only do we take a look at these but also the other general tools required for making not only silver jewelry but general items of jewelry as well.

**Tool 1 – Pliers**

There are several different types of pliers needed to make silver jewelry.

**Flat Nose or Chain Nose Pliers**

These are pliers you need for holding pieces with as well as for bending and forming the silver into a variety of different shapes and styles.

**Round Nose Pliers**

Without these pliers you will find it very difficult to create curves or circles. Plus like the flat nose pliers these can be used for bending wire.

**Half Round Pliers**

These pliers also help you to bend silver, but do so without them causing an outside curve to be created.

**Serrated Edge Pliers**

These pliers wouldn't normally be used when for actually making the piece of jewelry but used more for pulling wire through the jewelry or to straighten it out. But you need to be careful when using these as they can leave marks on the silver.

**Tool 2 – Jewelers Saw**

It's important you purchase the best quality saw you can. You'll notice that the blades come with blades of varying sizes. However initially I'd recommend you start with a saw that's fitted with a 1, 0 or 0/1 grade blade. You should only consider using saws with blades of grade 2 and upwards when you've been making silver jewelry for a while.

**Tool 3 – Files**

Just as with pliers there are several different types of files you'll need to help ensure you create and make some wonderful pieces of jewelry. The kinds of files you'll need to purchase are as follows:

**Needle File**

There are several different types of needle files you'll need to purchase. The main ones you will have to buy are for when you make a piece of jewelry that's flat, half round, oval and triangular.

**Large Flat File**

Without this type of file in your toolbox you're going to find removing solder from your pieces of silver jewelry difficult.

**Large Half Round File**

You'll find this file extremely useful when you need to clean and smooth the inside of any silver ring shank.

**Tool 4 – Ball Peen Hammer**

This is an essential tool to have as it can be used for making jewelry in a variety of different ways. Without this tapping (peening) silver pins, narrow joints or rivets into shape will be difficult.

**Tool 5 – Soldering Torch**

When you're selecting a soldering torch, make sure you go for a one that can be easily adjusted so it can produce either a wide or narrow flame. However it's worth considering purchasing two

soldering torches, as there is certain jewelry making tasks such as reticulation, which needs two torches to complete it. If you're going to purchase two torches then you should go for one that's hand held and the other that remains in a fixed position so the heat of the flame will also be directed towards the soldering block.

### Tool 6 – Charcoal Block

You'll need this for putting your pieces of jewelry on when carrying out any soldering work. By placing the piece of jewelry on this block you ensure any excess flame is actually being directed away from the surface of your work area.

### Tool 7 – Dish and Borax Cone

When it comes to soldering pieces of silver together it's important you use a flux. The most cost effective and easiest way to produce flux is through rubbing a borax cone in some water in a dish that's been specifically designed for this purpose.

### Tool 8 – Binding Wire

If you need to solder two or more pieces of silver jewelry together then you'll find this wire proves extremely useful. It enables you to free up both hands to carry out the work, as it holds the two pieces together whilst you're soldering. It's also great for casting.

### Tool 9 – Titanium Soldering Stick

There are plenty of books and guides about making silver jewelry but most fail to include this tool in their list. You need this tool to help position the item you're going to be soldering or annealing. As titanium has a much higher heating point compared to silver you'll need to have one of these sticks as it'll help to ensure not only is soldering trouble free but will also help to ensure the finished solder is smooth.

### Tool 10 – Insulated Tweezers

Silver Jewelry Making

You'll find this tool extremely useful when you're using the soldering stick above as it'll allow you to hold pieces of silver together as you solder them.

**Tool 11 – Vice**

This is another essential tool you'll need. A small one you can easily attach to your workbench or surface will suffice. Not only does it help to make the task of bending silver much easier but you can also use it for other purposes as well as holding the piece of jewelry in place whilst you're filing.

**Tool 12 – Safety Goggles**

You may not consider these to be an essential tool for making silver jewelry, but they'll help to keep you safe by protecting your eyes. They'll help to ensure your safety when you're soldering, cutting or filing the silver down.

# Chapter 2 – Materials Needed For Making Silver Jewelry

Before you start to make your jewelry you need buy various materials. What you don't want to happen is you get halfway through a project only to find you haven't got what's needed to complete it. So here's what you need buy:

**Material #1 - Wire**

Wire used for making jewelry with comes in four different hardness groups. There's dead soft, half hard, full hard and spring hard. Each one of these can be used in a variety of different ways.

Of course it's important to know a little more about the different levels of hardness as it'll help you to decide which one is best suited to the piece of jewelry you want to make.

**Dead Soft**

As this wire comes in a relaxed state at the molecular level you'll find it's very easy to bend, shape and hammer. However you need to be careful because if you work this wire too much it does gradually start to harden and can eventually break. You'll also find this type of wire has problems holding its shape especially when placed under any kind of stress such as being attached to a clasp or hinge.

**Half Hard Wire**

This wire has been worked a little before you've bought it and as result the wire grain becomes a little tighter on the molecular level. You'll not only find this wire a lot harder to bend but also to hammer, however, it's still possible to shape it, you just need to use a little more force than you would when using dead soft wire.

Although it's still malleable the great thing about this type of wire is it holds its shape better even when placed under some stress. This is the perfect wire to use when you need not only strength

but also a much thinner gauge wire to create your jewelry pieces with.

**Full Hard Wire**

This has been tempered (or hardened) and as a result is very difficult to bend, yet once you have been able to bend it into a certain shape it'll hold without any issues. I would recommend using this type of wire if you intend to make your own hinges or clasps.

**Spring Hard Wire**

This type of wire has been completely hardened and will have lost almost all of its malleability. If you were to try and bend this wire using just your hands you will find it'll immediately spring back into its original shape. However this type of wire is perfectly suitable for making jump rings, head pins and ear wires with.

One of the main things you should remember when it comes to using any of these wires is that their hardness is changeable. For example when it comes to dead soft wire the more you work or stress it the much harder it will become. Should you work it too much, eventually it'll end up breaking. Whereas when it comes to full hard or spring hard wire, if you were to heat it up either by soldering or annealing then it will start to soften. If you heat it up too much then the risk is it won't revert back.

**Different Types Of Wire**

**Type 1 – Sterling Silver**

This is relatively inexpensive to buy and is certainly less expensive than buying Gold. You also need choose one that contains 92.5% silver and 7.5% copper. If you plan on using sterling silver then be aware it will become tarnished because of the copper in it.

**Type 2 – Fine Silver**

This is much more expensive than sterling silver and would only recommend you buy this when you've had more experience. As

this type of wire is made up of 99.9% silver it won't tarnish over time, as sterling silver wire will. However as it can be fused to itself, when wanting to attach one piece to another you won't need to use a torch or solder.

**Type 3 – Argentium Silver Wire**

This is a new form of sterling silver wire. It contains a lot less copper as it contains more of the new material Argentium in it. Due to it containing a lot less copper you'll find it won't tarnish as much as normal sterling silver. However it does cost more than sterling silver wire. Again I would only recommend you use this type of wire when you have a little more experience.

**Wire Gauge**

You'll also need to consider what size gauge of wire you should be using. Wire comes in a variety of different sizes and some are more suitable for making certain pieces of jewelry than others.

The size of wire you should be using when it comes to certain silver jewelry projects is as follows:
- To make earrings – 20g (0.8mm) or 22g (0.6mm)
- To make clasps and hooks – 18g (1.0mm) to 20g (0.8mm)
- To make earring wires – 20g (0.8mm) or 22g (0.6mm)
- To make single loops for bracelets or necklaces – 18g (1.0mm) to 20g (0.8mm)
- To make wrapped loops in bracelets or necklaces – 20g (0.8mm) to 24g (0.5mm)
- To make spirals – 17g (1.2mm) to 20g (0.8mm)
- To make jump rings – 18g (1.0mm) to 20g (0.8mm)

Of course you can use different gauge wire if you want but this is meant to be a rough guide of what I use and find effective when making silver jewelry.

**Different Shaped Wire**

**Shape 1 – Round**

This is the shape that's most often used when it comes to making jewelry. It provides a much more uniformed and smooth finish to a piece.

### Shape 2 – Square

This should be used when making wire wrapped jewelry pieces. The reason being is this wire has edges that enable it to grip the surface of a stone or other piece around which it's being wrapped.

### Shape 3 – Half Round

Again like the square wire you'll find this one's suitable for making wire wrapped jewelry. Part of its surface is flat allowing it to grip the surface of another item better. But the round half helps to create a more even finish.

### Material #2 - Sheet Silver

Sheet silver gives you a lot more opportunities to create some truly amazing pieces of jewelry. Once cut, it can then be soldered, hammered or bent into a variety of different shapes and can make a variety of different pieces of jewelry. Not only can it be used for making actual pieces of jewelry but for making other pieces such as jewelry findings.

However there are certain things you should consider before you buy.

The first thing I'd suggest is to keep an eye on the precious metal market to see how much silver is going for on a daily basis. This way you can determine when the best time to actually place an order for some would be. Not only does the price per ounce of silver go up, it also goes down. So make sure you look at the price per ounce before you buy as it may be worth waiting until the price is at its lowest.

Another thing I'd suggest you do is only place a small order for sheet silver initially to ensure you get the right gauge. Be aware that once you've purchase it the seller won't allow you to return

it. Most places tend to sell it in sheets measuring 6 inches wide. However there are a few places that'll allow you to purchase custom cut sheets as well.

You're probably better off buying some copper sheets first so that you can judge the gauge that you'll need and give yourself some practice at using it. Remember if you over work the silver too much it can become hard easily and break.

If you're intending to source your sheet silver online then make sure you do so from a jewelry supply store that's been established for a number of years. Also look for stores professional jewelers prefer to use. Be aware that some stores may require you to provide evidence you're running a legitimate business before they'll supply you with your order.

### Material # 3 – Jewelry Clasps

When it comes to making silver jewelry it's vital you finish off each piece correctly. That's why it's worth investing money in good jewelry clasps as not only do they become an integral part of any design but they also help to ensure you create a professional looking piece of jewelry as they hide any ends that would otherwise be unsightly.

You'll find there are many different types of clasps to choose from. Some are quite elegant whilst others can be quite whimsical, but all will add a very professional finish to the piece of jewelry you've designed and created.

So what sorts of jewelry clasps should you be using?

### Type 1 – Adjustable Clasp

This particular clasp is made up of a hook and eye and usually comes with a small amount of chain attached to it. You should be using this type of clasp on a necklace, as it will allow the person to vary the length at which it's worn.

### Type 2 – Bar and Ring Toggle Clasp

This particular clasp is made up of two pieces. One piece of the clasp forms a loop and into this you thread the "T" shaped bar. The reason I've chosen to use this type of clasp is because it's so easy to use. I normally use this type when making bracelets, anklets or lariat necklaces.

### Type 3 – Bead Clasp

This type of clasp, as the name suggests, looks like a bead and uses either a magnet, bayonet or tab type closure to help keep the piece of jewelry in place when being worn. The thing I love about this particular kind of clasp is once closed it actually blends into the rest of the jewelry so it makes the piece look more pleasing on the eye.

### Type 4 – Box/Tab Insert Clasp

Unlike other clasps this one is made up of a tab that inserts into either a decorative box or frame. If you can afford to spend a little extra then try to buy the kind of box clasp that actually comes with a safety latch or chain, which prevents the tab from coming out and the necklace or bracelet will not fall off. Although most tend to be quite plain in design, you can get more elaborate ones, which have been decorated with enamel, gemstones or inlay work.

### Type 5 – Filigree Clasp

This form of clasp has an open filigree surface that looks very similar in design to lace. However it's made from metal rather than fabric and normally comes with a box or fishhook style clasp to allow you to keep both parts of the piece of jewelry together.

### Type 6 – Fishhook Clasp

These are quite small clasps in size and will come with an interior hook that looks similar in shape to a fishhook, which you then have to insert into an oval shaped box. The hook on this particular clasp helps to prevent the piece of jewelry you make from falling off when being worn should the clasp itself open accidentally as it hooks onto the crossbar inside it. This is ideal for

when you are thinking about making lightweight pieces of silver jewelry.

### Type 7 - Lobster Claw Clasp

This is a self-closing form of clasp and its name comes because of the way it looks. This particular clasp is spring-loaded and you'll find it's available in a number of different styles, shapes and sizes.

### Type 8 – Multi Strand Clasp

If you're making jewelry that's made up of 2 or more strands of wire then you should consider using this type of clasp. To help make this type look more elegant you can find some that have gemstones, enamel or inlay work added to them.

### Type 9 – Barrel/Torpedo Clasp

These are quite low profile clasps with threading and in order to open and close them they need to be twisted. This type of clasp is best suited for necklaces or anklets, as both hands are needed to open and close them.

### Type 10 – Magnetic Clasp

These are made up of two clasps and in each part there's a magnet and it's these that help the clasp to stay together. As well as helping to keep a piece of jewelry secure when being worn, you'll find taking the piece off is a lot easier because you simply need to very gently pull each side of the clasp apart.

### Type 11 – Slide Lock Clasp

This clasp is actually made up of a number of tubes with one of them sliding into the other and then locking into place. As this type of clasp is made up of several strands this is perfect for using on a necklace made up of a number of chains or wires.

### Type 12 – Snap Lock/Fold Over Clasp

Using this type of clasp because of its low profile means it's less likely to become tangled up in a person's hair or clothes when it's

being worn. This clasp is hinged and when folded shut, it helps to ensure the piece of jewelry to which it's attached remains locked securely in place. I use this type of clasp specifically when making bracelets or anklets.

## Type 13 – Springing Clasp

This particular clasp requires a jump ring or chain tab to be added at the other end of the jewelry. In order to open this clasp you need to pull the trigger. Be aware that as soon as you release the trigger the clasp then automatically closes. Just as with some of the other clasps discussed above, you'll find this one comes in a number of different shapes and sizes.

## Type 14 – Swivel Clasp

This type may look similar to the lobster clasp, but the way in which it works is completely different. In order for you to open and close it needs to be twisted 360 degrees. It's better used for anklets or bracelets.

## Material # 4 – Jewelry Findings

You'll find when making any kind of jewelry, not just from silver, these items are very useful indeed. As well as helping to keep items threaded onto the wire they also help to keep other materials in place you've incorporated into your pieces of jewelry.

These are the most common types of findings you will use when making any kind of jewelry:

## Type 1 – Crimp Tube and Cover

If you include a crimp tube and cover to your piece of jewelry you help to create a more refined and professional finish to it. I tend to place these on the ends of pieces that I've made as they work well as closures.

## Type 2 – Jump Ring

You should have a good supply of these findings in your jewelry kit, as they are extremely versatile. As well as helping to increase the length of a piece of jewelry; using a jump ring makes adding a charm, pendant or clasp a lot easier as well.

**Type 3 – Head and Eye Pins**

Of all the jewelry findings you need to buy, these are the first ones you should invest in. As well as coming in a variety of different shapes and sizes they come in a variety of different metals. You can also get some quite decorative ones and these can help to make a piece of jewelry look more unique.

**Type 4 – Bead Tips**

If you're intending to hang some beads or a pendant onto your jewelry then you'll need these. Not only do they help to make the task of fixing beads or a pendant to your piece a lot easier but also will help to strengthen the ends as well.

**Type 5 – Jewelry Links**

This type of finding is perfect for when you want to make a necklace a little longer or if you're going to use more than one chain or piece of wire in the design. Again like many other jewelry findings not only do these come in a wide range of different materials, but also in a wide range of different styles and sizes.

**Type 6 – Bails**

Do not be fooled by the simplicity of this particular finding, as they prove very effective when you wish to add a pendant to your necklace. Plus their simplicity adds a certain touch of class to the final piece as well. Not only do they help to ensure a more professional finish, they also help to make the piece to which they are attached stand out more.

# Chapter 3 – Techniques You Need To Master When Making Silver Jewelry

There are certain techniques you'll need to master if you want to create stunning pieces of jewelry you can either give away as gifts or to sell in order to make an additional income. In this chapter we'll go through some of the techniques you'll find yourself using the most often.

**Technique 1 – Preparing Dead Soft Wire**

Before you can begin working with dead soft wire you need to make sure it's free of kinks and as smooth as possible.

First you need to pull the wire through a polishing cloth as this will help to smooth out any kinks. If you wish to prepare three or four wires together then you should first pull each wire separately through the polishing cloth and then all together. By doing this you're making sure the wires are all flowing in the same direction, which makes it easier to sculpt them.

**Technique 2 – Annealing Silver**

This technique helps to soften the silver by applying heat to it. It's a very crucial technique you need to master as it plays a very important role when it comes to making silver jewelry. The temperature to which you need to get the silver to for annealing is between 1110 and 1200 degrees Fahrenheit. If the heat goes above this, the silver will start to melt.

The easiest way to carry out this technique is by using a blowtorch. Hold the flame on to the silver until it's begun to turn a dull pink in color. In order for the annealing process to be carried out correctly the correct temperature should be maintained for around 30 seconds. So you need to maintain this dull pink color for about the same amount of time.

To ensure this happens, you need to draw the flame into and way from the metal slightly, making sure the silver doesn't become overheated. When the silver does become overheated you'll notice it turns a bright orange/white color.

I would highly recommend when trying out this technique for the first time, you use a few scrap pieces of silver first. Not only will this help you to judge the colors better but also help you to improve your skills.

It's best when you wish to do any annealing that you carry out the task in an environment that's pretty dark. This way you'll be able to see better what color the flame is and what color the silver has begun to go.

It's also a good idea to brush the surface of the silver prior to annealing with some boric acid and alcohol.

When making certain silver jewelry items, be aware the only areas or joints need annealing is where soldering is going to occur, rather than the whole item. For example when it comes to making pendants or chains the bales will only need to be annealed.

Finally, when it comes to using the silver you've annealed it's important you carry out the final process of quenching. When you carry out this part of the process the silver should be a black color, because if you quench it whilst it's still red hot it can actually cause the silver to weaken. However if you would prefer the metal to age harden then let it cool slowly.

The process of quenching simply requires you to place the silver into some water for a few seconds.

**Technique 3 – Melting Silver**

Silver is the whitest of all pure metals found on this planet and when polished properly can end up with a mirror finish to it. It's this that's helped to make this metal such a popular choice when it comes to making jewelry or other types of ornaments.

Silver is very malleable and although heat is often used to help alter its design, it can be hammered into a variety of different shapes as well. However in this part of this chapter we are going to explain more about the two techniques you can use to melt silver.

**Method 1 – Melting Silver In A Kiln**

Step 1 – You place the pieces of silver into a heat resistant container normally referred to as a crucible and these tend to be made either from ceramic, clay or stone as they won't melt or soften when the temperatures reach a level that silver will melt at.

Step 2 – Now take the crucible, which you've filled with pieces of silver and place into a gas fired, or electric kiln and allow the silver to heat up. The silver will begin to melt once it's reached a temperature of 1435 degrees Fahrenheit. However this isn't the time when you should be removing it from the kiln you should in fact wait until the temperature of the silver has reached 1635 degrees Fahrenheit.

If you happen to be using silver for making jewelry that contains copper alloy be aware it won't be completely melted until it's reached a temperature of 1650 degrees Fahrenheit. You'll find if you're going to use a kiln to melt silver then a gas fired one will allow these temperatures to be achieved more easily.

Step 3 – As soon as the desired temperature as been reached you must turn the kiln off immediately and remove the silver from it using a long pair of tongs and some gloves. Once you've removed the crucible from the kiln then pour the melted silver directly into the mold that you've prepared, as once out of the kiln the silver will quickly start to cool and become solid once more.

**Method 2 – Melting Silver With A Torch**

Most people simply don't have the space or money available to melt silver using a kiln and this is why this method is proving so popular. Of course when working with hot metals, make sure you do so in a place that's well ventilated and away from others. It

may be a good idea to set up an area in your garage or garden shed where this work can be carried out.

To melt silver with a torch you need to carry out the following.

Step 1 – Begin by removing anything that's considered to be flammable from the area where you'll be working. To heat up the silver it's best to use an oxy-acetylene or oxygen-propane torch. The torch must produce an oxygen-assisted flame as this will help to ensure the desired temperature for melting silver will be reached. Of course you don't need to actually have to buy these torches; there are many places where you can hire them as well.

Step 2 – Just as with melting silver in a kiln, you need to place your pieces of silver to be melted into a crucible. Then place this on to a large piece of stone or into a box that's been filled with sand. The reason you do this is that both of these can withstand the heat from the flame of the torch.

Step 3 – Next you need to put on a welding mask, some thick gloves and an apron. If you haven't got these, again you may find the place where you hired the torch from hires these as well. However I would recommend you actually purchase them yourself, as you'll be using them quite often.

Step 4 – Once you've prepared everything and put on the protective clothing you can now light the torch. Then you need to adjust the preheating flame to a neutral position and its ready to use.

Step 5 - As soon as the flame is ready you move it down onto the crucible and then squeeze the oxygen valve. Doing this, will cause the heat emitted by the flame to increase. Now keep applying the flame to the silver until it's all melted.

The best way to check if it's all melted is by taking hold of the crucible with a set of tongs and tilting it very slightly. If you notice it all moving towards the edge then turn the heat off at once and again pour the silver directly into the mold you created earlier.

NB: Please remember to be very careful when working with molten silver as it can burn you very badly if it happens to splash or get poured onto your skin. Plus always make sure you wear good quality protective clothing and make sure the area in which you're working is completely clear.

## Technique 4 – Soldering Silver

Through soldering you're joining or fusing pieces of silver together by applying heat. Again when soldering silver, it's vital you wear the right kind of protective clothing. Not only should you be wearing a good pair of thick gloves and some safety goggles, but also a heavy-duty apron.

It's important to understand there are four different types of solder you can use for joining pieces together. We'll take a look at these before we look at the process of soldering.

### Type 1 – Enamelling Solder

This form of solder has the highest melting point. In order for it to melt, it needs to reach a temperature of 1490 degrees Fahrenheit. As the name would suggest this form of solder is only suitable for using when two pieces of silver need to be enameled to each other.

### Type 2 – Hard Solder

This type of solder tends to be made up of strips that measure about 6mm wide and the type you should be using first when wanting to solder two heavy pieces together. The melting point of this type of solder is much higher.

### Type 3 – Medium Solder

This type of solder measures 3mm wide and is often used after hard solder has been used but before the easy solder. However you may find this type of solder difficult to work with, as it can be very sticky.

### Type 4 – Easy Solder

These types of solder measures about 3mm wide but melts at a much lower temperature than the others. Generally this type of solder will melt at around 1240 degrees Fahrenheit. This type is best used for making very simple joints such as those used on findings or jump rings.

However before the process of soldering silver together can begin, there are certain other tasks that need to be carried out first.

Task 1 – You need to make sure the silver being used has been properly annealed first. (I have explained how this process needs to be carried out.)

Task 2 – Next it's important the silver to be soldered, has been thoroughly cleaned first. Even the minutest amounts of dirt left on the silver can cause the soldering to become tarnished. Also make sure the solder itself is clean and bright as when it becomes heated you'll find it begins to flow a lot quicker and easier.

The most effective method of cleaning silver ready for soldering is to use some detergent with a degreasing agent in it and an abrasive pad. Otherwise you can use pumice powder to remove any dirt or grease. After you've carried out either of these two cleaning tasks, make sure you clean each piece thoroughly. Of course if you would prefer a much easier way to clean the parts to be joined together is to steam clean them.

Task 3 – When soldering silver you need to make sure there are no gaps between the pieces you wish to solder to each other. By making sure there aren't any gaps you will prevent the solder from running down one side of the seam.

However if there are gaps between the joints or the two pieces are poorly matched then this may result in pitting of the solder. Plus it could actually create a joint that can very quickly and easily break. Sometimes it isn't possible to solder two pieces of silver together because they simply cannot be fitted against each other well.

## Silver Jewelry Making

Finally it's important to make sure you're using a good quality flux when soldering silver together. The best and most cost effective type of flux should be made from borax. Using borax will not only help to slow down the flow of the solder but also prevent it from becoming oxidized.

If you ensure the joint is oxide free you're actually helping to create the perfect surface for soldering to take place. So the finished article will look more professional as it'll be hard for people to identify where the two pieces have been joined together.

As soon as you've carried out the above tasks, you're now ready to begin the work of soldering your two pieces of silver together. To solder two pieces of silver together you need to carry out the following.

Step 1 – The first thing you need to do is make a paste, grinding some of the borax cone (flux) into a dish to which you add a little water.

Once you've made the paste, you now brush this on to both pieces of the silver you wish to join together. Although I am using pictures to illustrate how to make a silver ring the steps in this technique can also be used for soldering any item of jewelry together.

It's important when applying the flux you make sure, not only does it remain in contact with the solder at all times, but it also remains in contact with the two pieces being soldered together.

Step 2 - Now cut out a small piece of solder (paillon). For rings I would suggest you use easy solder. However for carrying out much more complex welds you should start off using hard solder, then apply a medium solder, followed by an easy one. You should place the small piece of solder you cut earlier just below or on the joint.

Step 3 – Next you need to heat the piece of jewelry very gently using a titanium stick to help you reposition the item. Whenever you're repositioning the piece make sure the solder stays in

position and make sure the heat is directed at the piece rather than at the solder, as this will become heated up through conductivity.

As soon as you notice the solder has become shiny and begun to run along the join then take the heat away and allow the item to cool for a few seconds.

When it comes to wanting to solder large pieces of silver together then it's best to use some binding wire to help keep the pieces in the correct position. Also it's far better to use a longer strip of solder for this task, which is more commonly referred to as stick soldering.

Also if you'd like to prevent the heat from the flame being conducted to other areas of the item, especially when making chains then you should isolate the parts that don't require soldering first. One particular method you can use is to place the part of the jewelry that doesn't need soldering into a dish containing cold water.

However if you're going to be setting a gemstone into any of your jewelry pieces it's best not to add these until after the soldering has been completed. If you do there's a risk the gemstone will become damaged, as heat will be conducted through to it.

Step 5 – Finally, after soldering of the two pieces has been completed the item then needs to be quenched. Simply place the soldered piece into a bowl of vinegar before rinsing it in clean water.

**Technique 5 – Casting Silver**

Through casting you're able to make items that are identical over and over again. There are three forms of casting that can be used.

Although we take a brief look at these below I have chosen to explain more about how to carry out cuttlefish casting.

**Form 1 – Commercial Casting**

To use this particular method you need to actually create a rubber mould first. However, once made it can be then be used over and over again.

## Form 2 – Lost Wax Casting

To use this form of casting, first you need to make a model from wax, which you then need to place inside either a metal flask or sleeve. Once you've done this, the flask or sleeve gets filled with a mixture made up of silica and plaster which is called an "investment". Then after this has been done it gets placed into a kiln so the wax then burns away and you're left with the investment that's actually the mould into which castings can then be made.

## Form 3 – Cuttlefish Casting

This is the simplest way for you to create a mould to cast the same item over and over again. Not only is this form of casting easy to use, but also it's very quick to use and enables you to make most basics shapes. The best place for actually purchasing cuttlefish is at your local hardware store or pet shop.

Now let's go through the process involved of cuttlefish casting.

Step 1 – You first need to cut a square out of the cuttlefish. It is important you cut this out of the thickest part. Once this has been done you now need to slice the bone half, so you have two flat pieces. Then take some sandpaper and rub this over the two pieces to make them smooth.

Step 2 – Now take a modeling knife and carve into one half of the cuttlefish the design you want. Then at the top most point of the design you need to carve a channel or deep groove through which the molten silver can then be poured.

Step 3 – As soon as you have finished cutting out your design and the groove, you now need to place the other half of the cuttlefish back on top. Then take some steel binding wire and wrap it around the two pieces of cuttlefish so they are held firmly in place.

Step 4 – Now very slowly and gently begin to pour the molten silver from the crucible into the channel you cut out earlier. Then leave the molten silver to cool before you cut the wire and then very gently prize the two halves of the cuttlefish apart.

Step 5 – Once you've opened up the cuttlefish you can finish off the piece of silver jewelry you have just made by pickling it first. Then smoothing the surface and edges down with filing paper.

If you're having problems getting hold of cuttlebones, you may want to consider using "delft clay" instead. This is a special clay system used for the process of casting. One of the major advantages of using it over cuttlebones is it produces a better surface to the finished product. However this type of clay is very expensive to buy and can only be used once because once it comes into contact with heat it immediately dries out.

If you do decide to use delft clay rather than cuttlebones you must not quench the mould in water, rather simply tap the mould and it should fall way.

A couple of things you should be aware of when it comes to casting pieces of jewelry, is if you're going to make more complicated pieces then several molds may be required to create these. Then once each piece has been cast, you can then solder them together later on. Plus if you want, the thinner pieces can be made to look even more spectacular either by being bent or hammered into different shapes.

Finally when it comes to casting you're going to be working at very high temperatures along with molten metal so make sure you carry out the work on a surface that's non-flammable. Also do not wear loose fitting and make sure you pour the silver very gently so that it doesn't splash.

**Technique 6– Creating Gemstone Settings from Tubing**

The process of creating gemstone settings from tubing is one of the easiest skills you can learn. In fact you'll find that tubing is the perfect material to use for creating custom settings for

gemstones, which can then easily be closed as long as you have a stone setting tool set.

To create the perfect setting from tubing for a gemstone, to incorporate into your pieces of jewelry, you need to carry out the following steps.

Step 1 – Carefully measure the width of the gemstone you wish to create the setting for. Once you have this measurement then choose a section of tubing into which it can be set, which is around 0.5mm wider than the stone.

NB: Please make sure the inside width of the tubing you're going to be using is smaller than the gemstone or it will simply fall directly into the tubing.

Step 2 – Next you need to cut a length of tubing, which is going to be long enough to contain the depth of the stone. Once you've done this you now need to file the edges of the tubing down so they are smooth, making sure you shape the bottom edge so it's in contact with the edge of the gemstone all the way round. Then solder the setting into place on your design.

Step 3 – Now take a hart or setting bur that's the same size or slightly smaller than the stone, which is going to be placed into the tubing, and cut a level seat into it that'll be just deep enough to hold the stone.

Step 4 – Once you've cut the level seat into the tubing you can now set the stone into it. But please make sure you leave a short rim of metal above the stone, as this is what will then be used to hold the gemstone securely within the tubing.

Step 5 – As soon as you are happy with the position of the tubing you can now secure the gemstone in place by burnishing the metal in a circular motion using a very highly polished punch.

**Technique 7 – How to Bend Tubing**

Step 1 – The first thing you must do is anneal the tubing as described in technique 2 of this chapter. By doing this you're

softening the metal a little so bending the tubing will be much easier.

Step 2 – Next you need to lubricate some wire that's no more than two-thirds the size of the inside diameter of the tubing that needs bending. This will then help to make removing it from the tubing after it's been bent much more easily. Once you've the wire is ready, thread this through the tube, as it will act as an Arbor.

Step 3 – Now very gently wrap the tubing around a mandrel or some other form that'll help you to create the bends you want. It is important as you carry out this task you make sure the wire is bending along with the tube, as this will then prevent kinks from appearing.

Step 4 – Once you've bent the tubing, remove the wire and allow the tubing to cool before incorporating into the rest of your silver jewelry design.

**Technique 8 – How to Hammer Silver**

Of all the techniques you need to learn for making silver jewelry this is the most basic one. The great thing about learning this technique is once you've mastered it for hammering silver you can use the same technique for hammering other soft metals such as aluminum, brass or copper. The tools you need to carry out this particular technique can easily be purchased locally at good crafts store or online.

To hammer silver you need to carry out the following:

Step 1 – The first thing you need to do is place the piece of silver you wish to hammer into an anvil block. It's important you make sure the side you wish to hammer is facing up towards you.

Step 2 – Now take the hammer in your right hand (left if left handed) and hold it about 3 inches below the head. Then with your free hand you must press down on the edge of the silver. If holding the silver is difficult because it's small, then use an anvil clamp instead. However if you're going to be hammering silver

that's going to form a ring you're best placing it onto a long metal ring holder.

Step 3 – Once the silver's in position very gently begin to tap the surface of the silver with the ball end of the hammer. You must start off softly and slowly because adding more dents is very easy, but taking them away can prove very difficult indeed. You need to keep gently tapping the silver until the desired textured effect you're looking for has been achieved.

Step 4 – Make sure you rotate the silver regularly and as you do, make sure you press down on the section that's already been hammered. Now repeat the same process as mentioned above for the next section of silver.

There are certain things you should be doing which will help to enhance and improve your hammering skills further.

1. Experiment. Take a piece of silver and try hammering it with both ends of the hammer to see what wonderful and different effects it can create.

2. Before you start work on any piece of silver, you should spend time practicing hammering on a scrap piece of metal first. This will also help you to learn how gently the metal needs to be hammered.

Above I have shown you just some of the techniques you need to learn in order for you to be able to make stunning pieces of jewelry not only for yourself but also for loved ones and friends. Plus once you feel you have mastered these skills you can look at selling pieces to earn an additional income.

# Chapter 4 – Some Projects To Try Out

Making silver jewelry isn't all that difficult even if you've never attempted it before. Certainly, once you've learnt even the most basic of techniques you can soon start making some wonderful and unique pieces of jewelry you can wear or give as gifts to loved ones and friends. Plus once you gain more experience and learn more techniques, you could possibly look at starting your own jewelry design business.

Of course there are certain things you need to consider before you begin work on any projects.

Now you've chosen the material in which you're going to make your jewelry, you now need to think about the design.

The best way to decide what type of jewelry you're going to make is to look at the type of jewelry you like wearing yourself, or pieces you see others wearing that you admire. Also don't forget to take a look through various magazines, online and in shops to see what sorts of designs are being favored at the moment. Then create your own based on these.

When it comes to choosing designs it's a good idea to collect any images you like and keep them in a book or folder so you can then refer to them when you start work on any projects.

Most people that decide to take up a new hobby will often go out and purchase a full range of tools, materials and supplies needed. But this isn't something you shouldn't be doing from the outset, as the amount of money you'll need to invest is quite substantial.

Instead it's much better to start off using kits first and when you feel your skills are starting to improve then look at buying what you need. Don't be afraid to gradually build up your inventory of materials, tools and supplies.

It's important before you go out and buy anything; you set yourself a budget first. Certainly in the beginning you should view the first few projects you carry out as a practice run. Not only will this help to save you money but will help to ensure you don't waste valuable and expensive materials creating pieces of jewelry that'll only get thrown away.

**So How Do You Go About Making Silver Jewelry?**

To make great pieces of silver jewelry you need to make sure you have the right supplies and have learnt the right techniques. Yes this book can help you to learn how to make jewelry from silver but I'd highly recommend you see if there's somewhere local that offers classes in jewelry making.

If you're having problems finding what you need locally there are plenty of places online that can offer you the tutorials to learn the skills for making silver jewelry as well. If you do find classes locally then make sure the person providing the training is someone who has experience of working with silver previously, ideally look for classes being taught by professional metalworkers.

Of course attending classes is all well and good but you need to practice what you have been taught. If you can, it's best you actually set aside a space especially for doing your work in. If you've s spare room in your home then convert this over to your studio.

When it comes to making silver jewelry there are certain things you need to do before you can commence work on any projects. The things you must do to prepare are as follows:

1. Gather the materials, tools and supplies you'll need to make your jewelry from and place these in somewhere in easy reach.

2. Next, if you've long hair, this should be tied back and if you are wearing any kind of jewelry especially the dangly sort then remove it.

3. It's important to make sure the space where you'll be working is free from clutter, well lit and well ventilated.

4. If you're going to be using any kind of torch make sure the tank has sufficient gas in it and check it over before each use. Look for any leaks that may cause the flow of propane from the tank to the torch itself.

5. Check the compound in which the silver is going to be pickled in is clean. If it isn't then you should prepare a new batch before you start work. In fact I would recommend you use a new batch of pickling compound for each project you work on.

6. Remember to wear the right sort of protective clothing; a pair of safety goggles, some thick gloves and an apron. It's also best to wear clothes, which should any silver happening to drip on them you won't be worried about damaging them.

7. Finally it's important you make sure before you begin any projects not only do you have the appropriate tools and materials, but also a copy of the pattern you're going to be creating your piece from.

Now you have everything in place you can begin trying out some of the projects below.

# Project 1 – Sterling Silver Hand Forged Hoop Earrings

If you are looking for a very simple project to begin with then making this pair of sterling silver hand forged hoop earrings should be considered.

Materials Needed:
1. 20 Gauge Sterling Silver Round Wire
2. 2 Smooth Ring Mandrels
1. Tools Needed:
1. A Pair of Round Nose Pliers
2. Polished Anvil
3. Plastic Mallet
4. Small Highly Polished Chasing Hammer
5. Tumbler
6. Burnishing Compound

Step 1 – Take the 20 gauge sterling silver round wire and cut off several pieces that are all of the same length using the round nose pliers.

Once you've cut each piece off, with the tip of the round nose pliers create a loop at one end of each wire.

The best way of removing any tool marks from the wire is by burnishing it with the tips of the pliers by rotating them in the loop. After you've done this, the wire should look shiny and round and should be free from dents.

Step 2 – Next round the ends of the wire off with a 1mm cup burr. Then take a plastic mallet and shape the wire into a circle on a smooth ring mandrel. The easiest way for you to do this when using hard wire is to wrap it firmly at the end of the mandrel. Then you simply slide it up and tap with the mallet before taking hold of the next wire.

Step 3 – Once all the wires are circular, bend up the rounded ends of the earrings into a curve and place each one on to the polished anvil and begin to flatten them lightly all around with the highly polished chasing hammer.

Select a chasing hammer, which comes with a head that measures 1 inch or more. As you flatten out the earring make sure you focus on the centre part as much as possible. Only tap the metal lightly as any harder will cause it to become deformed.

It will take around 20 seconds for you to complete this task on each earring. Plus you mustn't rush this part of the process otherwise mistakes will be made and the earrings won't turn out as you'd like.

Step 4 – Before placing the earrings into a tumbler with some burnishing compound, make sure each earring is the same size and shape as the other. By putting them in the compound they'll come out looking a lot shinier and also slightly harder.

NB: When it comes to using the anvil and the chasing hammer, make sure these are kept as clean as possible, so before you use them clean them down to remove any silver filings or grit. If you don't, not only will this cause deformities in the earrings but will also damage the silver.

# Project 2 – Simple Drop Earrings

Of all the pieces you can make from silver these are among the simplest. By adding semi precious stones to them or little funkier by using beads, you can create some stunning designs.

Materials Needed:
1. 2 Headpins or Eye pins
2. 2 Ear wires (Sterling Silver If Possible)
3. Beads or Semi Precious Stones of Your Choice
4. Spacer Beads

Tools Needed:

A Pair of Round Nose Pliers

Step 1- Take the head pin and thread some beads or semi precious stones. If you intend to make drop earrings using beads, then placing a spacer bead between each one as this helps to break up the beads.

Step 2 – Once you've threaded the beads or semi precious stones onto the headpin you now need to create a loop. To do this take your pair of round nose pliers and very gently bend the head pin over until an angle of 90 degrees is achieved. Then bend the head pin over the pliers until a loop has been completed.

Steps 3 – After creating the loop attach some French wire or other finding for earrings and they're ready to wear.

# Project 3 – Sterling Silver Ring

It's quite possible for you to make your own sterling silver ring using this very simple technique. This is the same technique that experienced metal smiths have been using for centuries to create such pieces of jewelry.

Materials Needed:

12 to 16 Gauge Sterling Silver Wire

Tools Needed:
1. Ring Mandrel
2. Ball Peen or Forming Hammer
3. Jewelry Saw
4. Jewelry File
5. Sandpaper
6. Butane Torch
7. Solder
8. Bowls and Pickle Compound

Step 1 – Cut a piece of sterling silver wire and wrap this around the ring mandrel until a ring is formed in the size you need. If you're making a ring for someone with quite small fingers use thin 16-gauge wire. However if the ring is for someone with much larger fingers (guys for example) then make their ring from a thicker 12-gauge wire.

Step 2 – After wrapping the wire around the mandrel very gently hit it with the ball peen or forming hammer until it starts to take the shape of a ring.

Step 3 – Now cut off any excess wire using a jewelry saw. Although it's possible for you to cut off any excess wire using a pair of wire cutters, by using a jewelry saw you'll find the cut is much cleaner and will sit flush against the other wire. In turn this makes soldering the two ends of the ring together much easier.

Step 4 – After you've cut off the excess wire, take the file and sand the ends until a perfect ring is formed. Then with a pair of pliers and a hammer, you need to very gently, bring the two ends of the ring together, making sure they're tight against one another.

Step 5 – Now take a small amount of solder and place above the two ends of the ring. Then turn the torch on and bring close to the solder and keep it there until it's melted and the two ends of the ring are fused together.

Step 6 – As soon as you've completed soldering the two ends of the ring, place into the bowl with the pickle compound and leave there for a minute or two. Then remove and rinse in clean water then dry it off.

Step 7 – Now place the ring back on the mandrel again and file around where the two ends have been soldered together with the file and sandpaper until the area is smooth. Then place in a bowl with some burnishing compound to polish the ring up.

Step 8 – Finally check to make sure the ring is the right size for the person who is going to be wearing it before placing it in a box to present to them.

As you can see when it comes to making silver jewelry rings this is the simplest process of them all.

Janet Evans

# Project 4 - Diamond Drop Necklace

This particular project will create a piece that looks wonderful when teamed with a simple white blouse or a little black dress. Although I have used Czech black diamond drops and black druks, you can replace them with any other gemstones you like.

Once completed the necklace will measure around 17.5 inches, however if you need to make it longer or shorter this can easily be achieved through adding more beads or taking a few beads out.

Materials Needed:
1. 2 Packs Silver Lined 6mm Pony Beads
2. 2 Packs Black 4mm Druks
3. 1 Pack Black Czech Top Drilled Diamond Shaped Drops
4. 1 Pack Sterling Silver Figure Eight Jump Rings
5. 1 Pack Silver Plated Crimp Beads
6. 1 Pack Sterling Silver Lobster Claw Clasp
7. 1 Spool SoftFlex Medium Sized Beading Wire

Tools Needed:

1 Pair Crimping Pliers

Step 1 - Cut of around 20 inches of the SoftFlex beading wire and then thread it through a crimp bead before then threading it through the loop of the lobster clasp and then back through the crimp bead. Once you've threaded the wire back through the bead, push the bead close up to the clasp and with your crimping pliers crush the bead closed. Any additional wire should then be trimmed off.

Step 2 – Now take 1 of the Druks and thread this on to the other end of the wire and then thread on 7 pony beads. Repeat this process 6 more times.

Step 3 – Next string on another Druk followed by 3 pony beads and 1drop bead and then follows this with another 3 pony beads. Again repeat this pattern 4 more times.

Step 4 – After completing step 3 you need to thread on 1 Druk and 7 pony beads again (See step 2). Repeat this process 6 more times making sure the final item you place on the thread is a Druk.

Step 5 – Now you need to add on the other part of the lobster clasp. To do this first thread on a crimp bead followed by the figure of 8 jump ring and then threading the wire back through the crimp bead. Again make sure the crimp bead is tight up against the figure of 8-jump ring before closing the bead with the crimp pliers.

# Project 5 – Wild Orchid Evening Necklace

You will find that, in order to complete this project you need to be willing to push your skills a little more. However once created it will look lovely worn with your favorite little black dress when going out for dinner or to some party this Christmas or New Year.

Once made the necklace measures 20 inches at its longest point.

Materials Needed:
1. 1 Pack Swarovski 4mm Mystic Black Round Pearls
2. 1 Pack 4mm Amethyst Rounds
3. 1 Pack 4mm Amethyst Fire Polished Crystals
4. 1 Pack Preciosa Amethyst Bicone Crystals
5. 1 Pack Preciosa Jet Bicone Crystals
6. 1 Pack Silver Plated Filigree Tube Beads
7. 1 Pack Silver Plated Liquid Twists
8. 1 Pack Silver Plated 3mm Rounds
9. 1 Antique Silver Plated Abstract Tulip Connector
10. 1 Pack Silver Plated Oval Filigree Clasps And Hooks
11. 1 Pack 4mm Silver Plated Jump Rings
12. 1 Pack Silver Plated Small Corrugated Crimps
13. 1 Spool Fine SoftFlex Beading Wire

Tools Needed:
1. 1 Pair Crimping Pliers
2. 1 Pair Wire Cutters
3. Pair Bead Stoppers

Step 1 – Take the SoftFlex beading wire and cut off four pieces. 1 Piece should measure 8 inches long, another should measure 14 inches, the third one should measure 15 inches, whilst the final piece of beading wire should measure 17 inches long. Now take a bead stopper and clip this to one end of the three longest strands you've just cut.

Step 2 – On the 14-inch strand, string onto it a crimp bead before bringing the end of the wire through the bottom of a Tulip

connector and then back through the crimp bead. Once threaded back through the crimp bead close it using the crimping pliers. Any excess should be trimmed away and now you can start to thread on the beads in the following order.

Start off by threading on 4 Liquid Twists follow by one silver round then 1 Jet Bicone. Then thread on another silver found, 4 Liquid Twists, 1 Amethyst Bicone, a filigree tube and another Amethyst Bicone. Repeat this pattern once more and then add on to the wire, 5 Liquid Twists, 1 Swarovski Pearl, 5 Liquid Twists, 1 Amethyst Fire Polished Crystal, 8 Liquid Twists and 1 Crimp. Make sure you place the crimp bead next to a closed jump ring.

Step 3 – Now take the wire measuring 15 inches and again, start off by adding a crimp bead, then crimp this strand to the left of the strand you've already completed in the step above.

On to this strand you will thread the following in the order stated. Start off by threading on to the wire, 3 Liquid Twists followed by 1 Silver Plated Round then 1 Jet Bicone, then 1 Amethyst Round followed by another Jet Bicone followed by another Silver Round and then finish off by threading on 3 Liquid Twists and 1 Swarovski Pearl. Repeat this pattern another 3 times on this strand before adding a final 13 Liquid Twists and a crimp bead. Make sure you crimp this strand to the same closed jump ring you did in step 2.

Step 4 – Now you take the SoftFlex beading wire measuring 17 inches long and to this you add a crimp bead which you then close after you have placed it to the left of the wire threaded in step 3. Once it's securely in place you can now begin to thread on the beads in the following order.

Begin by threading on 3 Liquid Twists followed by 1 Silver Plated Round, then thread on 1 Amethyst Fire Polished Crystal followed by 1 Silver Plated Round then this should be followed by 3 Liquid Twists, 1 Amethyst Bicone, 1 Filigree Tube and 1 more Amethyst Bicone. Now repeat this pattern another four times on to the wire and finish off with 8 liquid twists and a crimp bead. Crimp the bead to the closed jump ring before attaching the jump ring to the filigree clasp.

Step 5 – All you now have left is the 8-inch strand and to this first add a crimp bead and before closing it attach the strand to top of the tulip connector. Once you've completed this task you can now string the following on to it.

Start off with 1 Liquid Twist followed by 1 Swarovski Pearl, then thread on another Liquid Twist followed by an Amethyst Bicone. Then after this thread on a Filigree Tube, another Amethyst Bicone, another Liquid Twist and a Swarovski Pearl. Finally thread on 10 Liquid Twists and a crimp bead. Thread the wire through the hook portion of the clasp before threading back through the crimp bead and closing it with the crimping pliers. Again make sure any excess wire is trimmed off before the necklace can be worn and enjoyed.

# Project 6- Sterling Silver & Gem Flower Necklace

Not only is this necklace very simple to make but also it looks extremely elegant and can be worn with just about any kind of outfit. Plus women of all ages will enjoy wearing this particular one. If you are making for anyone in particular find out what their birthstone is and use this is the gem for the centre of the design so making it very special and very unique.

Materials Needed:
1. 1 Sheet 22 Gauge Sterling Silver
2. Jump Rings
3. Genuine Semiprecious Stones
4. 6mm Bezel Cups

Tools Needed:
1. Saw and Saw Blade
2. Masking Tape
3. Extra Fine Point Sharpie or Other Marker Pen
4. File
5. 220 and 180 Grade Sandpaper
6. Flux
7. Small Paintbrush
8. Easy, Medium and Hard Silver Solder
9. Micro Torch and Butane
10. Pickle (Acid compound that you have in a pot that you will be using to clean the silver with after it has been fired)
11. Copper Tongs
12. Two Part Epoxy Resin
13. Objects With A Sharp Point (An Old School Compass Will Suffice)
14. Burnishing Tool
15. Brass Brush
16. Wooden Handled Tweezers

Janet Evans

It's important before working on this project you make sure you have everything to hand and there's sufficient gas to help light the torch.

Step 1 – First, off take the sheet of sterling silver and cut a piece that measures 2.5 inches wide by 3.5 inches long. Then along the 2.5-inch side, place a strip of masking tape.

Step 2 – Now with the sharpie, draw on the tape, a circle freehand that measures about 6.5mm and then draw six petals separately. Once done each of the items drawn should be in a row along the masking and of course will not resemble a flower as yet.

Step 3 – Take your saw and cut out the images you've drawn onto the masking tape. Once you've cut all seven pieces of silver out, place them to one side ready for use later, not forgetting to remove the masking tape from them first.

Step 4 – Now take the file and use this to round out each piece you've just cut as well as smooth off the edges and each side of the sterling silver should then be rubbed briefly with sandpaper.

Step 5 – Place some flux on the round piece of the sterling silver with a small paintbrush. This piece of silver is the centre of the flower. Then put 6 pieces of hard solder around this piece of silver on top of the flux, make sure you place them evenly around the circumference. Now take the lit torch and place the flame onto the piece of silver and keep it there until you start to see the solder begin to sweat. As soon as you notice the solder is sweating take the torch away and turn it off.

Step 6 – Now take each one of the petals you've cut out and place these on top of the solder you've just heated up. Now the pieces together should start to look like a flower. Once all the petals are in place, turn the torch on again and direct the flame towards the petals and the solder. This time you need to wait until the solder has melted and the pieces of metal that form the petals have settled down onto the other piece of sterling silver.

Silver Jewelry Making

Step 7 – Next take this piece and place in the compound (pickle) using the copper tongs and leave in their for a few minutes. When the time has elapsed remove from the compound, again using the copper tongs, before immersing in clean water. This will help to remove any of compounds from the metal.

Step 8 – After rinsing the flower in clean water remove and with the 220-grade sandpaper begin rubbing the edges of the flower down to make them smooth. Do the same for the front and back of the flower.

Step 9 - When you feel the flower is smooth enough, place to one side and now take a small jump ring and flatten it out. Then take the flower and turn it over so the rear of it is showing and onto one of the petals place some medium solder. Then direct the flame from the torch towards this solder until it starts to sweat then with the wooden handled tweezers place the jump ring on the sweating solder and heat it up once more until it begins to melt so ensuring the jump ring is then fixed to the flower. After doing this, place the flower back in the pickle.

Step 10 – Whilst the flower remains in the pickle take one of the 6mm bezel cups and sand the walls of it down until they're fairly low using the 180 grad sandpaper. Once you've done this, remove the flower from the pickle and rinse it off in some clean water.

Step 11 - Once clean apply some flux on to the front of the piece at the centre of the flower. Now place a piece of easy solder on to the flux and again heat it with the flame from the torch until it starts to sweat. As soon as it begins to sweat take the torch away and place the smoothed bezel cup onto the solder then bring the torch back and continue to heat until the piece settles down onto the solder. As before take the flower and place in the compound (pickle) and leave for a minute or 2 before then taking it out and rinsing it in clean water. Then dry the item off.

Step 12 – Now with the brass brush very gently scrub the silver until it regains its shine. Then with the old compass create a crosshatch pattern inside of the bezel cup.

Step 13 – Next with a toothpick mix together the two part epoxy resin and with the same toothpick dab some of the resin into the bezel cup attached to the flower and then place the 6mm stone into the cup. Leave this alone for 20 minutes to allow the epoxy to set and ensure the stone won't fall out.

Step 14 – Now burnish the edges of the bezel cup so they hug the stone keeping it securely in place then thread a sterling silver chain through the jump ring at the rear of the flower and the necklace is ready to wear.

When it comes to making silver jewelry there are certain important things to remember to ensure you carry out your projects safely. The most important things to remember are as follows:

1. Be sure the area in which you are working with pickle compound and soldering equipment is well ventilated. Both of these give of gases that can prove detrimental to your health.

2. Make sure when cutting wire or when filing wire down you wear safety goggles at all times. Even the smallest piece of wire could cause serious damage to your eyes.

3. It's important when using a soldering torch you have the correct fire safety procedures in place just in case something untoward occurs. Also make sure after you've finished using your torch you've turned it off properly and don't lay it down on any surface after you've just used it.

4. Spend some time actually reading through the instructions that are provided with the torch and pickling compound so you know exactly how they need to be used.

5. Make sure when working with the pickling compound you never touch it with your hands but to place in and remove items of jewelry using a set of tongs.

6. Although some projects may suggest the wearing of gloves it is best to avoid doing so as these decrease the sensitivity in your

fingers. However please be cautious when working with the soldering torch and pickling compound.

7. Even though you may not think it is necessary, make sure you have a good quality first aid kit close to hand.

# Here's More Kindle Jewelry Making Books from Janet Evans

Printed in the USA
CPSIA information can be obtained
at www.ICGtesting.com
CBHW070254030724
11009CB00010B/876